301

THINGS
TO DRAW

301

THINGS
TO DRAW

chartwell
books

CALLING ALL ARTISTS!

Do you have trouble coming up with ideas, or struggle with issues like art block? Then these prompts are just what you need to pull you out of your slump!

These 301 drawing ideas are designed to get your creative juices flowing through sketching items from everyday life to more fantastical forms that will have your imagination running wild in no time. It's good to know how to draw the mundane and the whimsical as both can help you create your own original characters and environments.

Tapping into the deep recesses of your mind while looking at the prompts is important for your development as both an artist and critical thinker. Daydreaming and letting your mind wander are essential to harnessing your own personal techniques.

To help clear your art block, draw some of these 301 items in different and unique styles. Try drawing a prompt upside down or with your eyes closed, or even attempt to create a piece using just a single continuous line. Another idea is to try combining the prompts on the page together to create one large scene complete with a variety of characters.

Art is a spectrum and there is something for everyone. Breaks and blocks are okay, but if it is something you love, it will always be there when you need it.

Happy drawing!

1. Coral Reef

- -

2. Swing

3. Your Zodiac Sign

4. Crown

5. Wishing Well

6. OC (Original Character)

7. Umbrella

- -

8. Puddle Reflection

9. Wasp or Bee

. .

10. Honeycomb

11. Shipwreck

12. Zen Garden

13. Lighthouse

14. Camera

15. Something in Front of You

. .

16. Cat

17. Treefrog

18. Wolf

. .

19. Bunny

20. Mermaid

21. Music Box

22. Windmill

23. Origami

24. Water Park

25. Flora & Fauna

26. Disco Ball

. .

27. Rollerblades

28. Lava Lamp

. .

29. Bubbles

30. Yin & Yang

31. Zentangle

32. Dreamcatcher

34. Post-Apocalyptic Vehicle

35. Bonfire

- -

36. Campsite or Tent

37. UFO

38. Cow

39. Moustache

40. Makeup

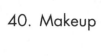

. .

41. Haute Couture

42. Hoverboard

43. Fortune Teller

44. Moose

45. Figurines

46. Lady Justice

47. Shattered Glass

48. Spider Web

49. Scales

- -

50. Lace

51. Space Helmet or Astronaut Suit

52. Maze

53. Horns or Antlers

54. Salt & Pepper Shakers

55. Self Portrait

56. Bear Cub

57. Butter Dish

. .

58. Fork

59. Wrapped Present

60. Balloon Animal

. .

61. Cherry Bomb

62. Clown

- -

63. Fireworks

64. Basket of Berries

65. Train Tracks

66. Your Favorite Movie or Book Character

67. Koi Pond

. .

68. Jack 'o' Lantern

69. Movie Theatre

70. Pop Corn

71. Typewriter

. .

72. Film Reels

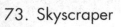

73. Skyscraper

. .

74. Sunflowers

75. Slippers

76. Gown

77. Angel

78. Demon

79. Futuristic Travel

. .

80. Croissant

81. Knight

82. TV Remote

··

83. TV

84. Sandwich

85. Videogame Controller

86. Graffiti

87. Scissors

- -

88. Puzzle Pieces

89. Watermelon

90. Cupcake

91. Zeppelin

92. Vampire

93. Werewolf

94. Sword

95. Thimble

96. Fairy

97. Mushrooms

. .

98. Button

99. Robot

. .

100. Light Switch

101. Vending Machine

102. Roller Coaster

103. Skeleton

104. Blender

105. Milkshake

106. Bar Stool

107. French Fries

108. Yeti

109. Planet

. .

110. Pizza

111. Festival

112. Ticket

113. Ancient Ruin or Shrine

114. Pretzel

115. Pencil

· ·

116. Paintbrush

117. Propeller Plane

. .

118. Dancer

119. Voodoo Doll

120. Unicorn

121. Fountain of Youth

122. Alphabet Blocks

123. Porcelain Dolls

124. Teddy Bear

. .

125. Crayons

126. Witch

127. Pyramids

128. Pebbles

129. Waterfall

. .

130. Waves

131. Tower

132. Potion

133. Cauldron

134. Candle

. .

135. Skull

136. Sculpture or Statue

- -

137. Rainbow

138. Castle

139. Dinosaur

140. Mountain

141. Succulent

142. Beach

· ·

143. Surfboard

144. Manhole Cover

145. Newspaper Stand

146. Dragon

. .

147. Glasses

148. Bridge

. .

149. Cowboy Hat

150. Jester Mask

151. Garden Gnome

· ·

152. Pool Float

153. Fence

. .

154. Soda Can

155. Superhero

156. Supervillain

157. Goddess

158. Wings

159. Scarf

160. Postcards

161. Polaroid Pictures

162. Suitcase

163. Dollhouse

164. Boat

. .

165. Goggles

166. Feather

. .

167. Horse

168. Melting Ice Cream

169. Jellyfish

· ·

170. Fish

171. Clouds

- -

172. Telescope

173. Ghost

· ·

174. Watering Can

175. Praying Mantis

176. Throne

177. Meadow

. .

178. Narwhal

179. Toolbox

180. Drill

181. Workshop

· ·

182. Safe

183. Treehouse

184. Chessboard

185. Ray Gun

186. Gears

. .

187. Vase

188. Milk Carton

- -

189. Cookies

190. Holiday Decorations

. .

191. Cuckoo Clock

192. Cityscape

193. Bike

194. Car

. .

195. Walkie-Talkie

196. Bus

197. Pocket Watch

198. Crystal

199. Tooth

200. Herbs

201. Phone Booth

202. Fairy Lights

203. Giraffe

204. Alien

205. Photo Booth

· ·

206. Smile + Toothbrush

207. Knit Sweater

. .

208. Sewing Kit

209. Lamp

210. Wine Glass

211. Loaf of Bread

212. Chair

213. Footprints

214. Forest

215. Lava

216. Bucket

- -

217. Sandcastle

218. Seashell

219. Picnic

220. Puppet

221. Face

222. Eyes

223. Hands

224. Raven

225. Claws

226. Zombie

. .

227. Graveyard

228. Shoes

229. Playing Cards

· ·

230. Sloth

231. Teacup

232. Lantern

233. Coat Hanger

· ·

234. Clothing Rack

235. Fan

236. Laundry Hamper

237. Treasure Chest

238. Keys

239. Side Profile of Face

240. Door

241. Tree Bark

242. Icicles

· ·

243. Ice Skate

244. Snowman

245. Streetlight

246. Violin

247. Ears

248. Leaf

249. Tornado

250. Wig

. .

251. Facemask

252. Nail Polish

. .

253. Bouquet of Flowers

254. Bonsai Tree

255. Bat

256. Bird Nest

257. Garbage Can

258. Avocado

259. Backpack

- -

260. Water Bottle

261. Box of Chocolates

262. Lock

263. Crevice

264. Computer

265. Button-Up Shirt

266. Fire Hydrant

· ·

267. Ladder

268. Pigeon

. .

269. Scooter

270. Pan Flute

· ·

271. Moon & Stars

272. Rosebud

273. Snail

274. Orange Slices

275. Talisman

276. Bow & Quiver

277. Book

. .

278. Wizard's Wand

279. Candy Wrappers

280. Compass

281. Mailbox

282. Locket

283. Record Player

284. Headphones

285. Guitar

286. Flip Phone

287. Stethoscope

288. Chainsaw

289. Donut

290. Snowflake

291. Soap

. .

292. Bathtub

293. Lily Pads

· ·

294. Windowsill

295. Butterflies

- -

296. Sunrise or Sunset

297. Staircase

298. Asymmetrical

· ·

299. Bird Eye's View

300. Close Up

. .

301. Fish Lens

*PICK A SUBJECT AND DRAW IN THESE STYLES